last supper

when it was evening, he took his place with the twelve; and while they were eating, he said, 'truly i tell you, one of you will betray me.' and they became greatly distressed and began to say to him one after another, 'surely not i, lord?' he answered, 'the one who has dipped his hand into the bowl with me will betray me. the son of man goes as it is written of him, but woe to that one by whom the son of man is betrayed! it would have been better for that one not to have been born.' judas, who betrayed him, said, 'surely not i rabbi?' he replied, 'you have said so.'

while they were eating, jesus took a loaf of bread, and after blessing it he broke it, gave it to his disciples, and said, 'take, eat; this is my body.' then he took a cup, and after giving thanks he gave it to them, saying, 'drink from it, all of you; for this is my blood of the covenant, which is poured out for many for the forgiveness of sins. i tell you, i will never again drink of this fruit of the vine until that day when i drink it new with you in my father's kingdom.'

matthew 26: 20–9

this, the earliest surviving representation
of the last supper, derives from the common
roman feast: the disciples recline around a
horseshoe-shaped table, jesus occupying
the place of honour on the left. he raises his
hand as if in speech, and from the reaction
of the apostles – most of whom stare at
judas seated at the far end of the table – we
can infer that he has just announced his
impending betrayal.

mosaic
early 6th century
san apollinare nuovo, ravenna

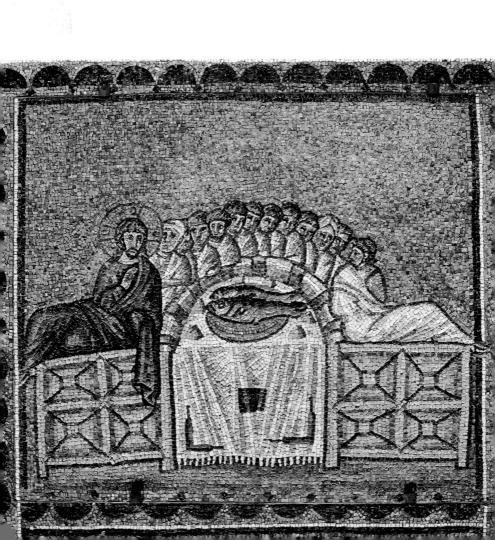

this is the first time that the cup containing
the eucharistic wine is included in a scene
of the last supper. it is here given special
prominence in the centre of the
composition immediately in front of christ.

illuminated manuscript
c.600
corpus christi college, cambridge

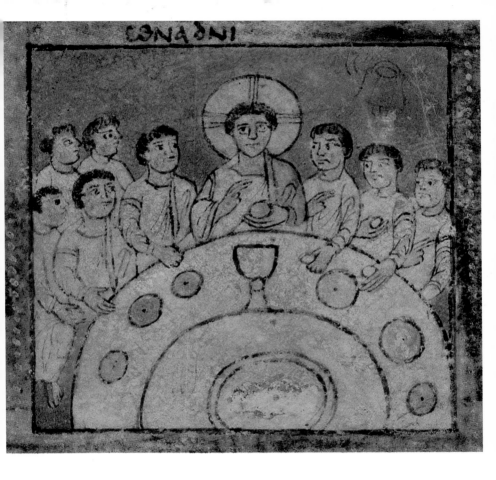
CENA DNI

ivory relief

c.900

british museum, london

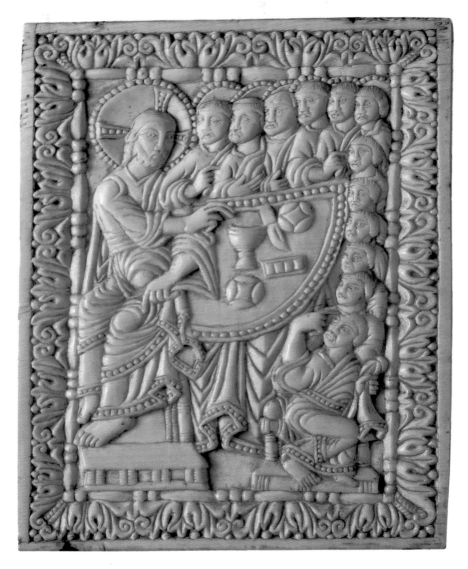

enamel plaque
c.976
san marco, venice

illuminated manuscript

c.1000

abbey of saint gall

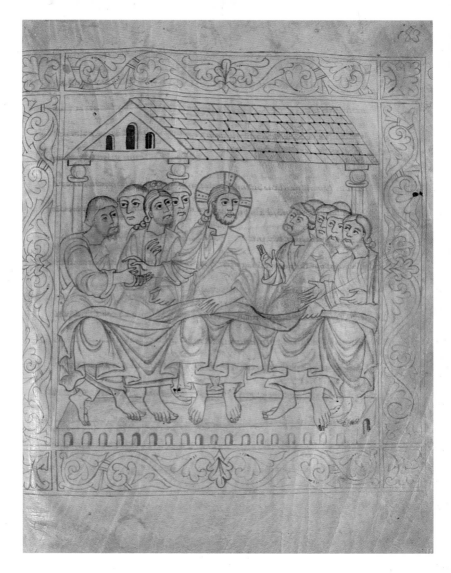

judas is identified here and in many
subsequent representations by his reaching
towards one of the vessels on the table, in
accordance with the words at matthew
26: 23, where christ identifies his betrayer
as 'he who has put his hand into the
dish with me'.

illuminated manuscript
1007 or 1012
bayerische staatsbibliothek, munich

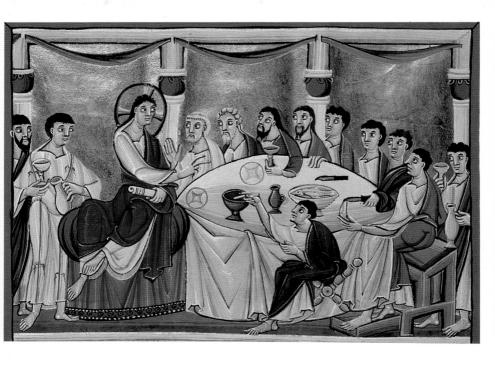

the motif of saint john asleep on christ's
shoulder or lap which is frequently found
in representations of the last supper refers
to john 13: 23: 'one of his disciples – the
one whom jesus loved – was reclining
next to him.'

illuminated manuscript
c.1043–6
escorial, madrid

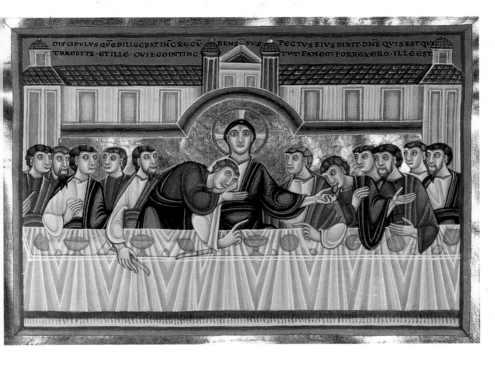

DISCIPVLVS QVEDILIGEBATIHC RECV BENS SVP PECTVS EIVS DIXIT DNE QVIS EST QVI
TRADET TE ET ILLE CVI EGO INTINC TVM PANEM PORREXERO ILLE EST

wooden door panel

c.1050

st maria in kapitol, cologne

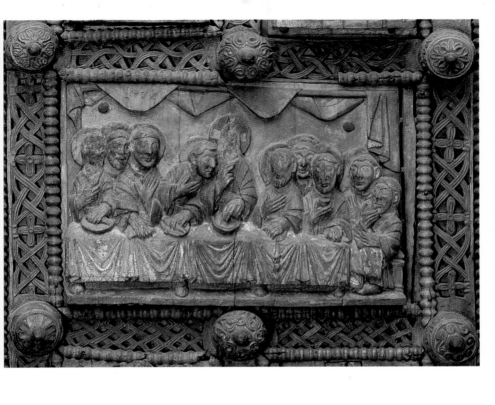

illuminated manuscript
c.1050
pierpont morgan library, new york

(overleaf)
fresco
11th century
sant'angelo in formis, capua

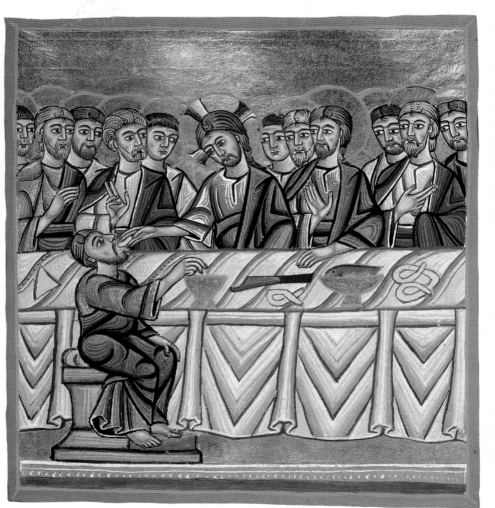

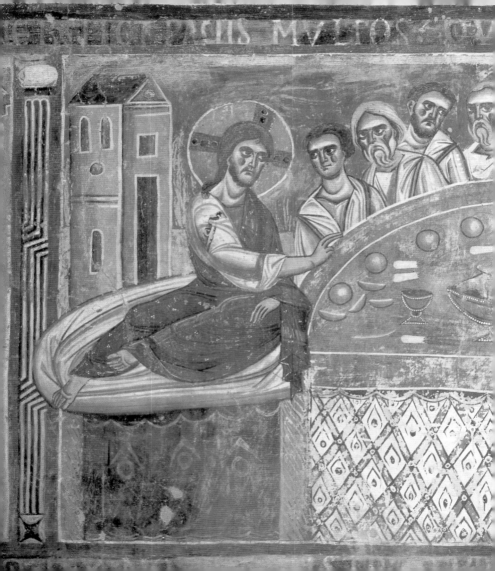

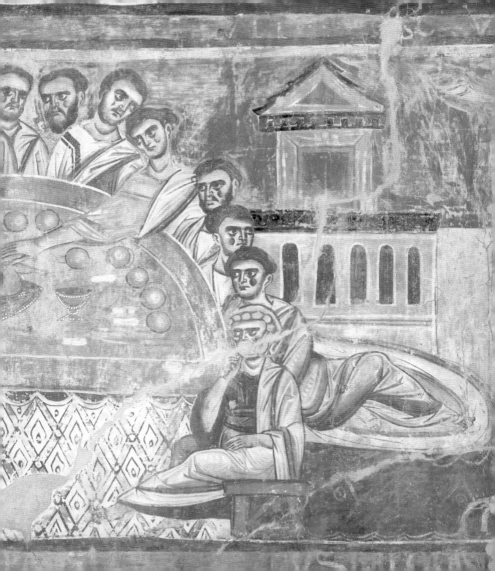

as judas receives the bread from christ,
a small black devil is shown entering
his mouth.

illuminated manuscript
c.1140
bayerische staatsbibliothek, munich

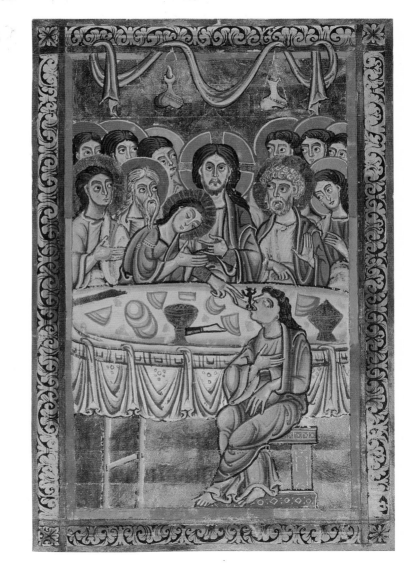

stained-glass window
c.1150
chartres cathedral

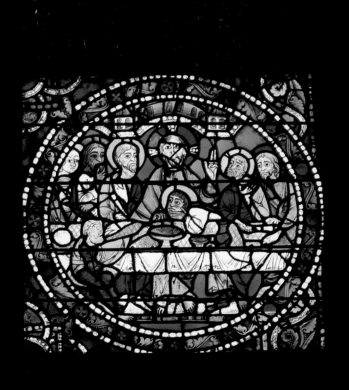

in the gospel of john, jesus's announcement
of his impending betrayal is preceded by an
episode in which he washes his disciples'
feet. the artist here combines the two
events in a single frame.

.

illuminated manuscript
c.1153
british library, london

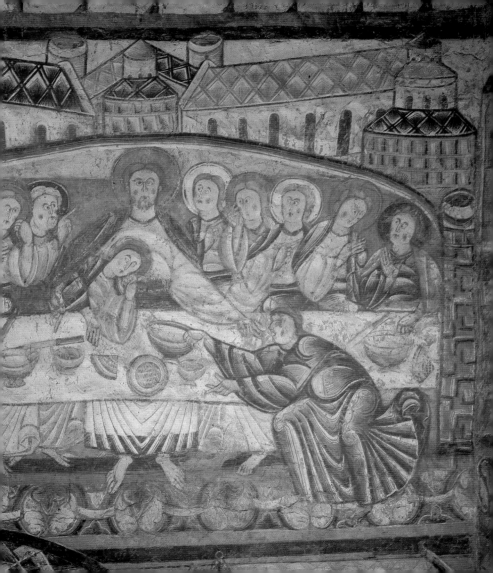

as judas receives the bread from christ
he hides a fish behind his back. this refers
to an episode in one of the passion plays
when judas, ever treacherous, steals food
from the table.

nicholas of verdun
enamel plaque
1181
klosterneuburg abbey

anselmo da campione

painted marble

c.1184

modena cathedral

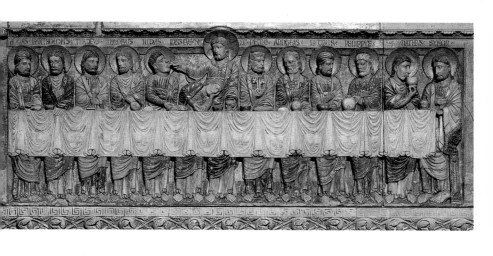

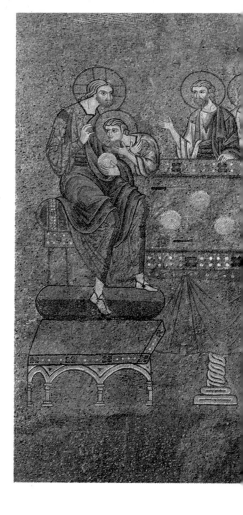

mosaic
late 12th century
san marco, venice

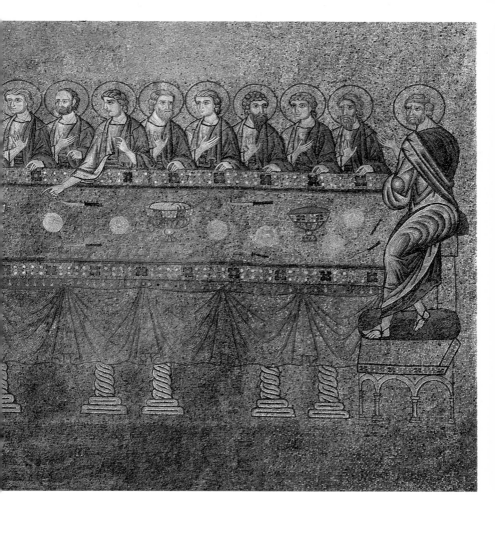

saint peter can frequently be identified as
the apostle who holds a knife, or sits with
one in front of him – a reference to the
incident where he cuts off a servant's ear
during christ's betrayal.

illuminated manuscript

c.1210

musée condé, chantilly

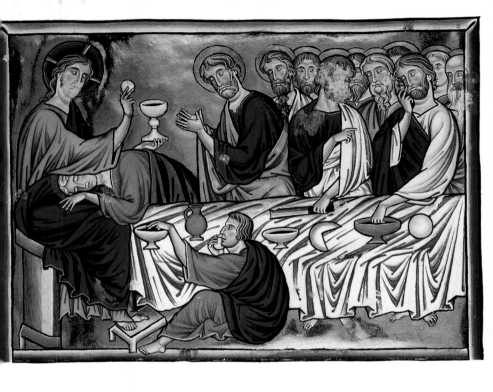

naumburg master
painted stone
c.1260
naumburg cathedral

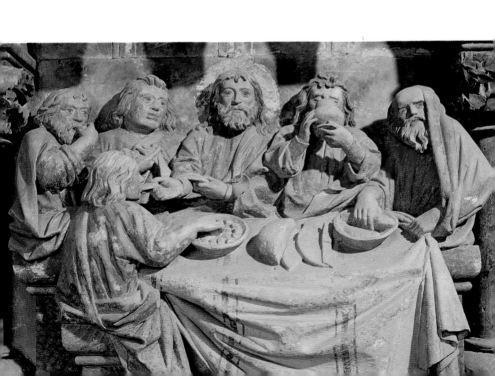

saint peter, with his grey hair and curly
beard, usually sits near to christ and often
on his right hand. this seating-plan
emphasizes peter's seniority and his
importance as the future founder of the
church in rome.

giotto
fresco
c.1305
scrovegni chapel, padua

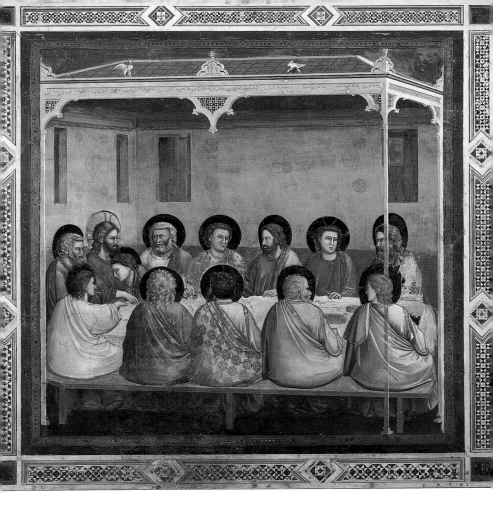

duccio

tempera on wood

1308–11

museo dell'opera del duomo, siena

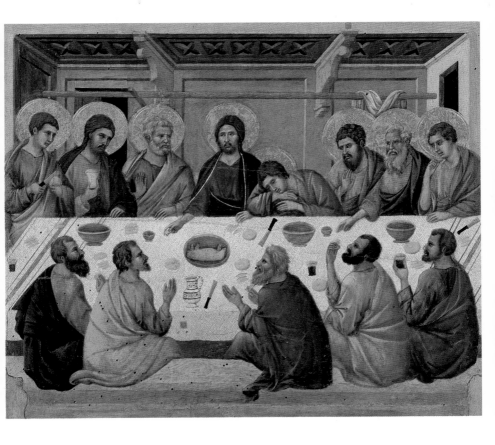

where the apostles are shown with haloes,
that of judas may be black, or missing
altogether, as it is here.

pietro lorenzetti
fresco
c.1315
san francesco, assisi

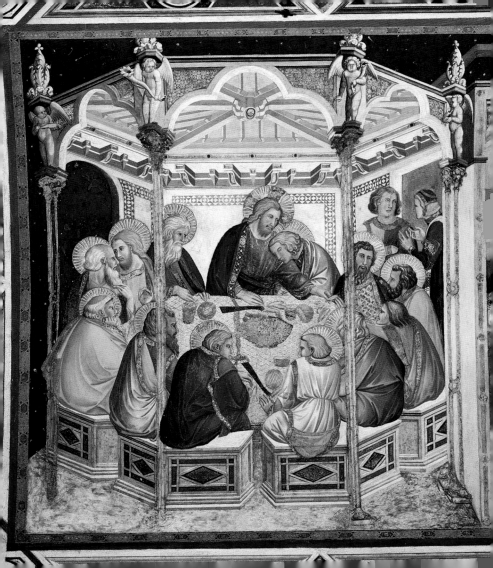

fresco

c.1317

pomposa abbey, ferrara

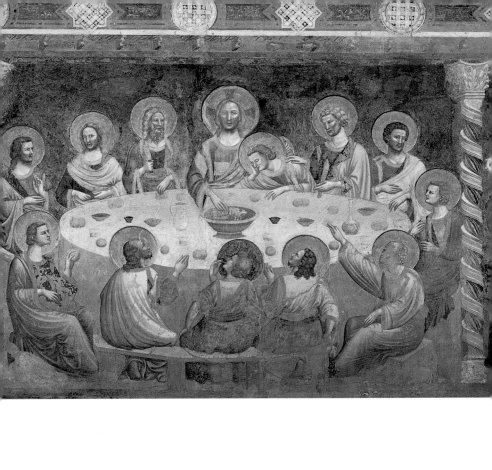

here judas is challenged by one of the
apostles as he attempts to slip away
unnoticed.

taddeo gaddi
tempera on wood
1330s
accademia, florence

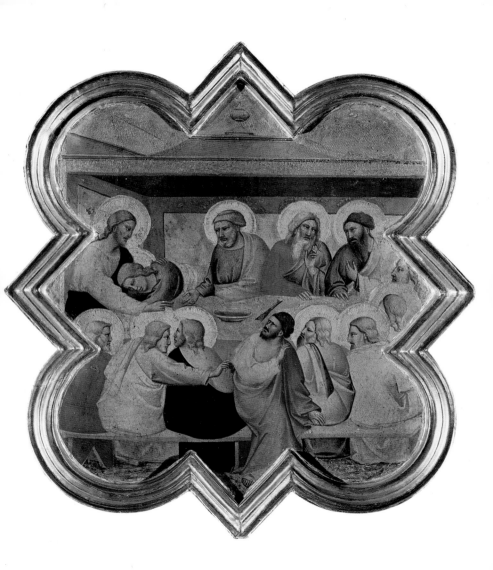

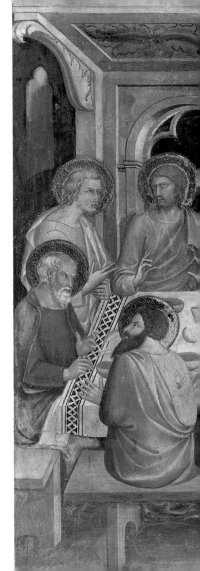

the last meal which christ took with the
disciples before his arrest was a celebration
of the jewish feast of the passover,
commemorating the leading of the israelites
out of egypt. as lamb was one of the foods
associated with this feast, it often appears
in the centre of the table.

barna da siena
fresco
c.1340–50
collegiate church, san gimignano

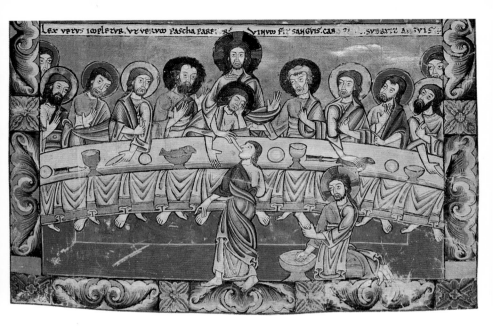

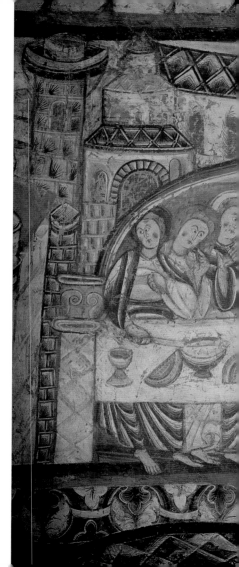

fresco
mid-12th century
saint martin, vic

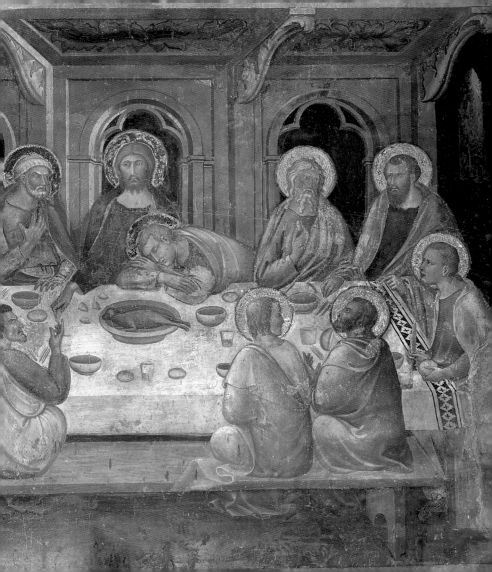

lorenzo monaco

tempera on wood

c.1400

gemäldegalerie, berlin

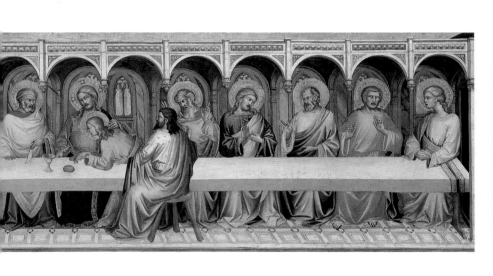

lorenzo ghiberti

gilt bronze panel

1403–24

baptistery, florence

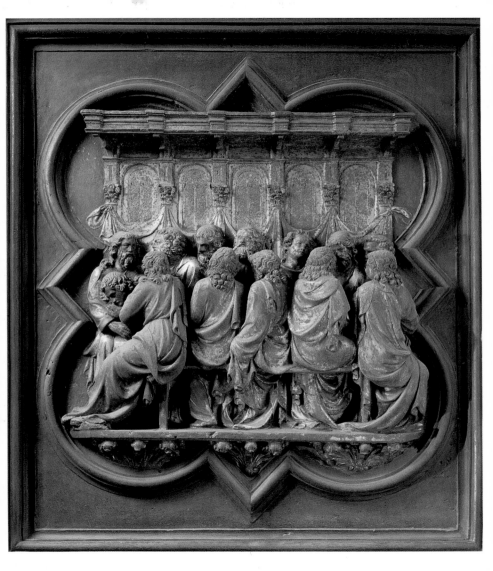

pietro di zanino

tapestry

1420–30

san marco, venice

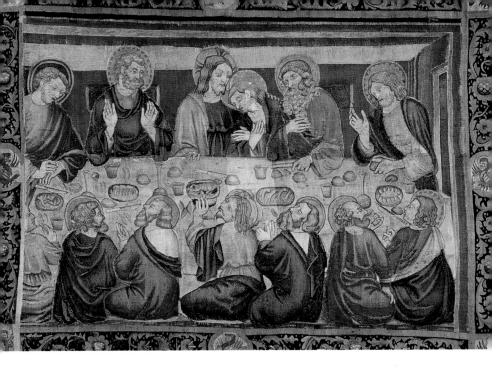

sassetta

tempera on wood

1423

pinacoteca nazionale, siena

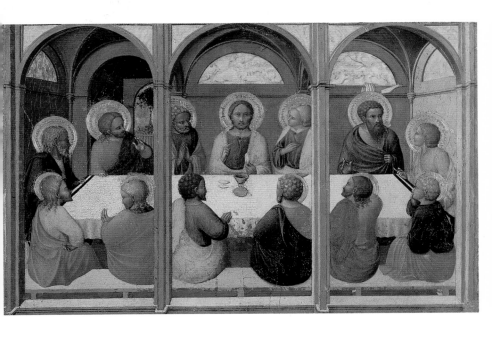

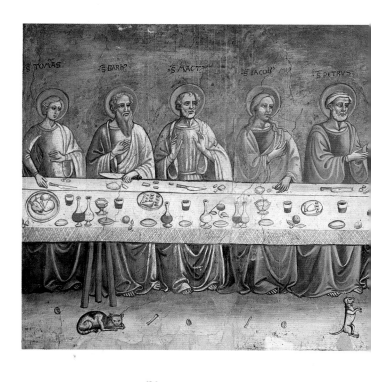

judas is here identified not only by his
black halo, but also by a conspicuous
money-bag containing the thirty pieces of
silver for which he betrayed christ. this
becomes his most obvious attribute.

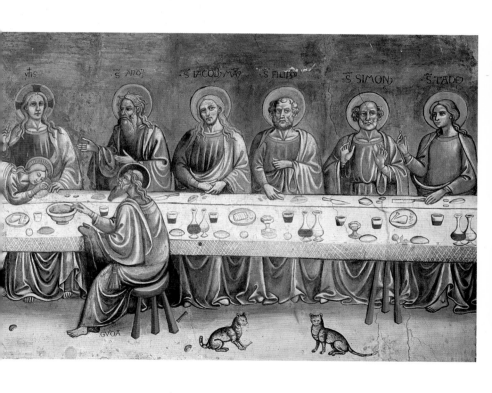

stefano di antonio vanni

fresco

c.1434

san andrea a cercina, florence

the words and the actions of christ as he
blessed the bread and wine at the last
supper came to form the main ceremony
of the christian church – the eucharist
or mass. often, as here, artists chose to
highlight this more symbolic aspect
of the story, resulting in scenes that
contemporary worshippers would have
recognized immediately.

fra angelico
fresco
1438/1442
museo di san marco, florence

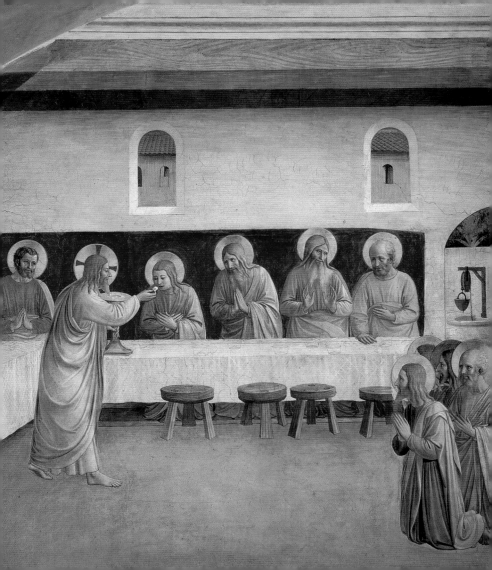

master of catherine of cleves

illuminated manuscript

c.1440

pierpont morgan library, new york

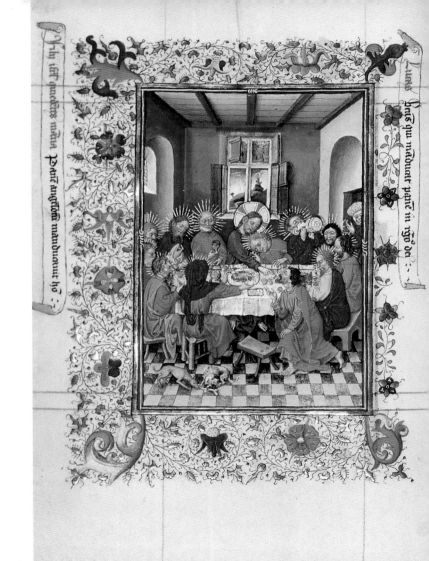

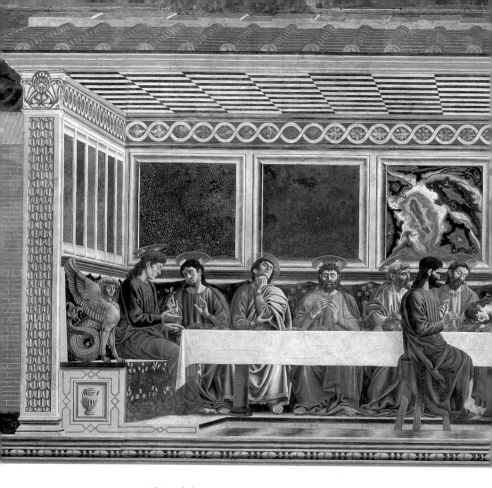

andrea del castagno

fresco

1447

sant'apollonia, florence

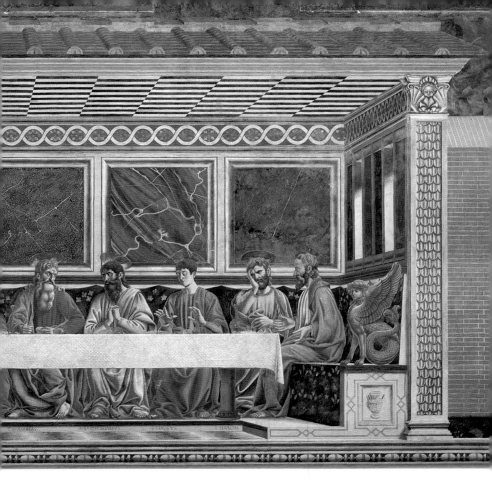

ANDREAS S·BORTOLOMEVS S·TADEVS S·SIMON

fra angelico
tempera on wood
c.1450
museo di san marco, florence

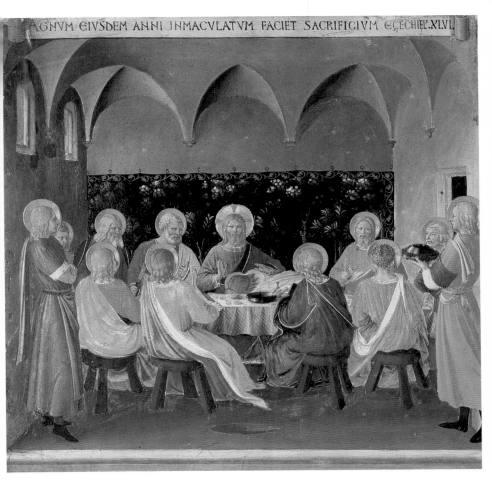

fra angelico

tempera on wood

c.1450

museo di san marco, florence

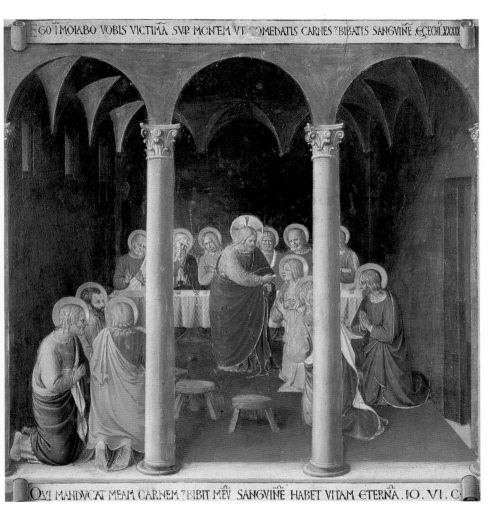

IMOLABO VOBIS VICTIMA SVP MONTEM VT COMEDATIS CARNES 7BIBATIS SANGVINE ECECHI.XXXIX

QVI MANDVCAT MEAM CARNEM 7BIBIT MEV SANGVINE HABET VITAM ETERNA. IO. VI. C

jaime huguet

tempera on wood

c.1450–60

museu d'art de catalunya, barcelona

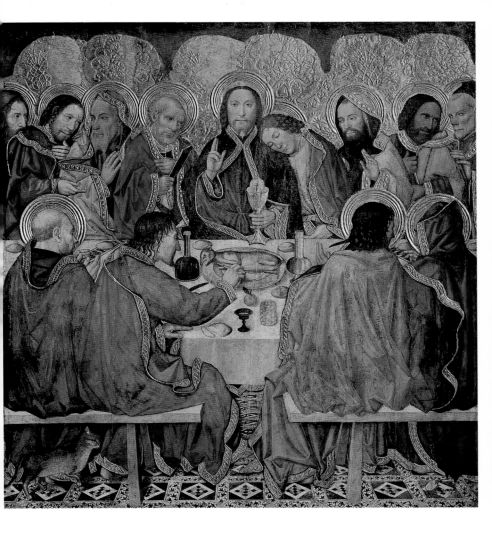

jean fouquet
illuminated manuscript
c.1452
musée condé, chantilly

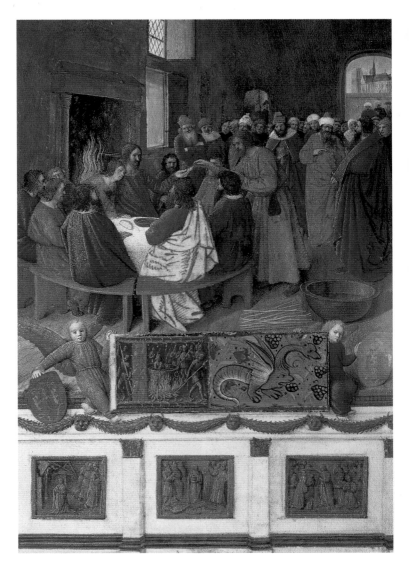

this is the first time that a central panel
of an altarpiece has been devoted to the
last supper: as the faithful of the church
of saint peter's received communion,
they would have looked up and seen a
realistic representation of the event
it commemorates.

[handwritten note:] furiousness? arrogance of Judas's hand on hip

dirck bouts
oil on wood
1464–8
collegiate church of saint peter, leuven

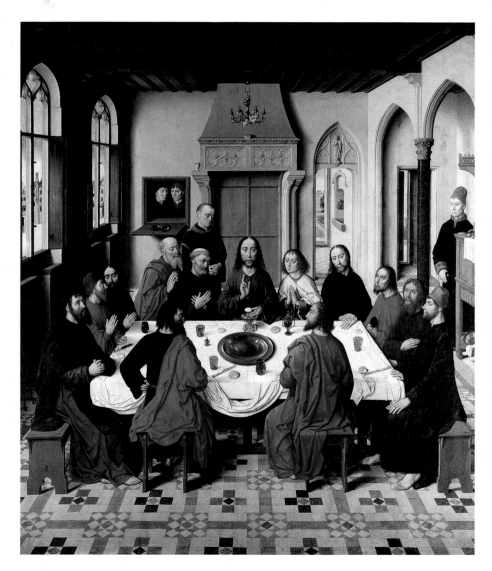

justus of ghent

oil on canvas

1473–4

palazzo ducale, urbino

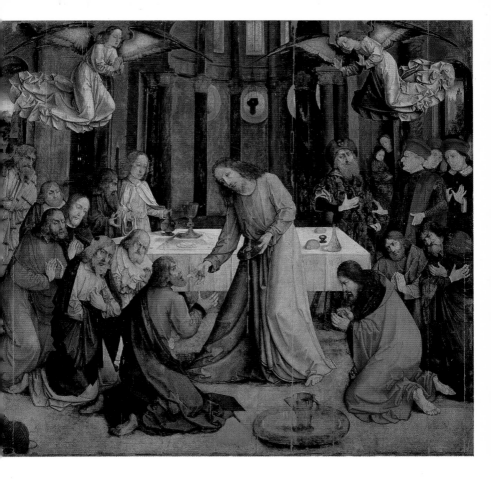

cosimo rosselli
fresco
1481–2
sistine chapel, vatican, rome

(overleaf)
domenico ghirlandaio
fresco
c.1482
museo di san marco, florence

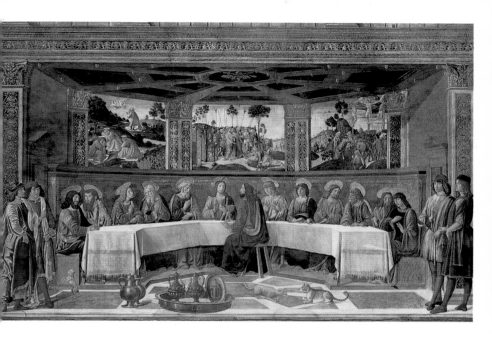

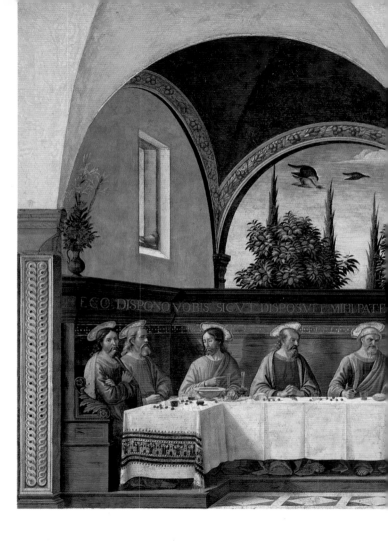

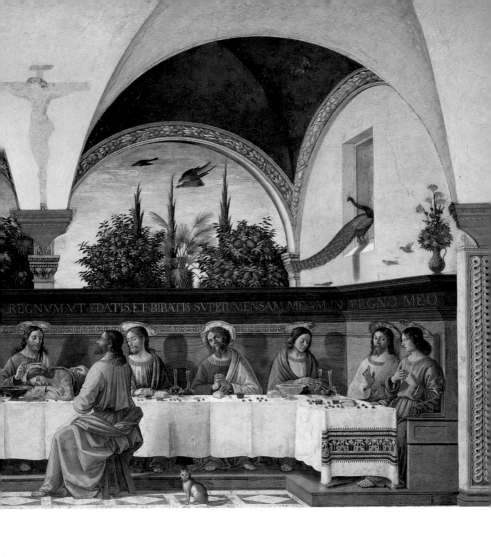

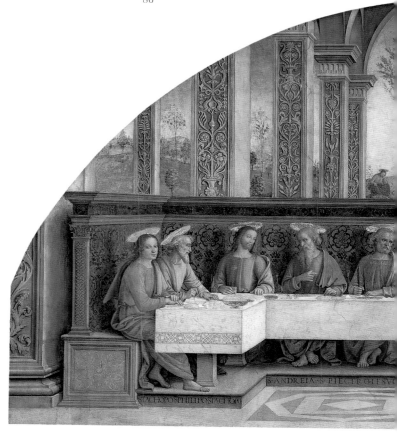

pietro perugino

fresco

late 1480s

san onofrio, florence

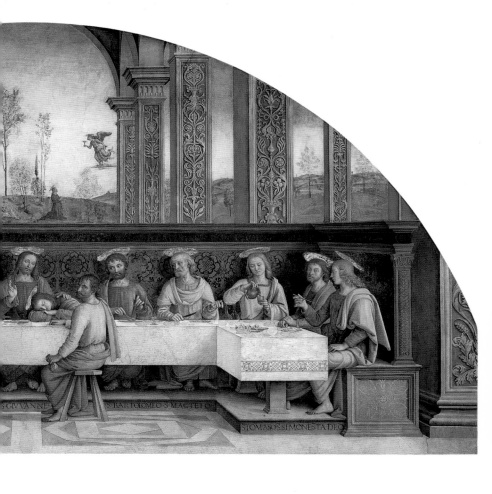

giovan pietro birago

illuminated manuscript

c.1490

british library, london

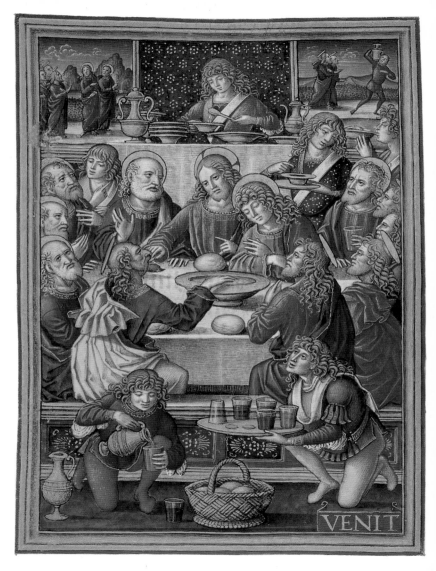
VENIT

in this, one of the most admired paintings
of all time, leonardo is the first to make the
sacramental event into a convincing human
drama – he focuses on the diverse and
subtle reactions of each of the apostles
who hear christ's announcement that he
will be betrayed.

leonardo da vinci
tempera on plaster
c.1495
santa maria delle grazie, milan

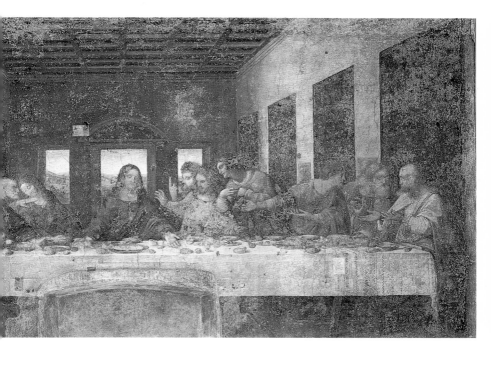

ercole de' roberti

tempera on wood

1490s

national gallery, london

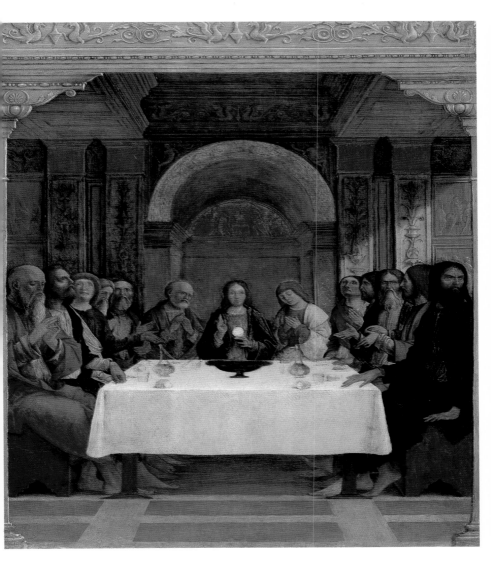

flemish school
illuminated manuscript
15th century
musée condé, chantilly

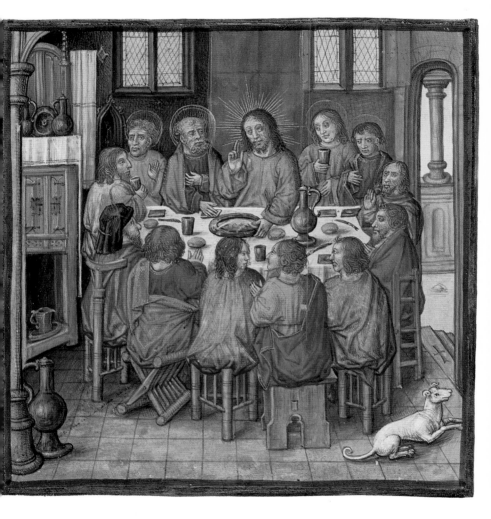

tournai school
tapestry
15th century
vatican, rome

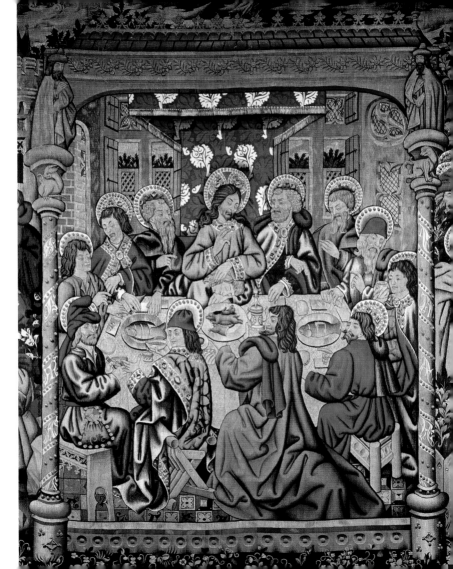

simon bening
illuminated manuscript
c.1500
pierpont morgan library, new york

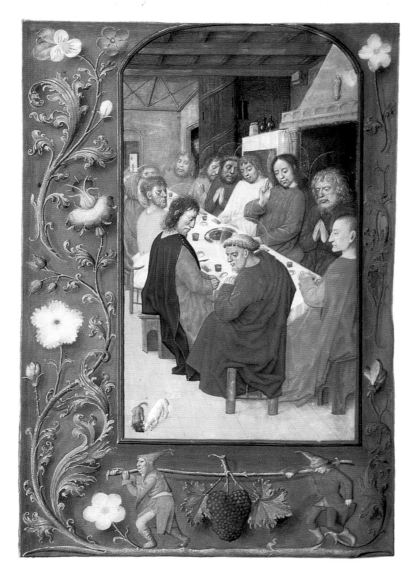

this great altarpiece was commissioned
by the town council of rothenburg as a
reliquary to house a drop of christ's blood –
an important relic which had drawn large
numbers of pilgrims to the church.
riemenschneider has focused on the
personal aspect of the drama to encourage
viewers to meditate on it closely. unusually,
judas has taken the place of christ in the
centre of the composition.

tilman riemenschneider
carved limewood
1501–5
jakobskirche, rothenburg ob der tauber

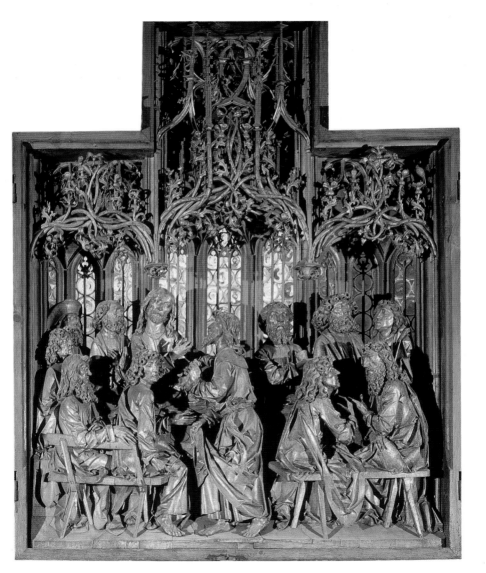

master of the van groote adoration

oil on wood

c.1510–20

metropolitan museum of art, new york

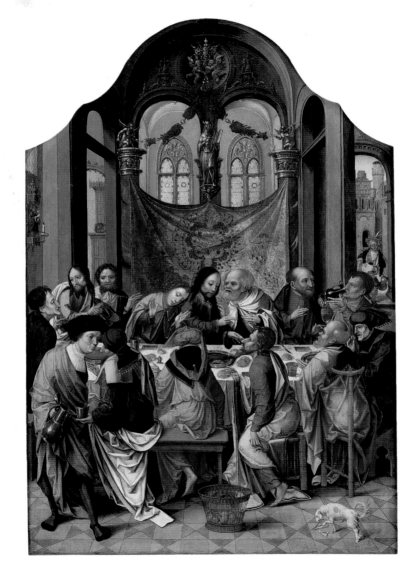

luca signorelli

oil on wood

1512

museo diocesano, cortona

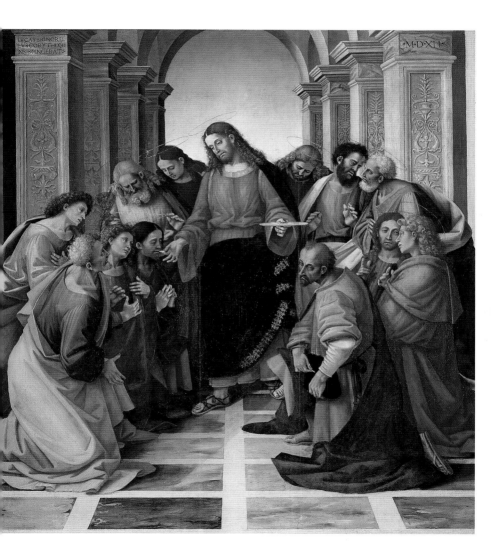

albrecht dürer

woodcut

1518

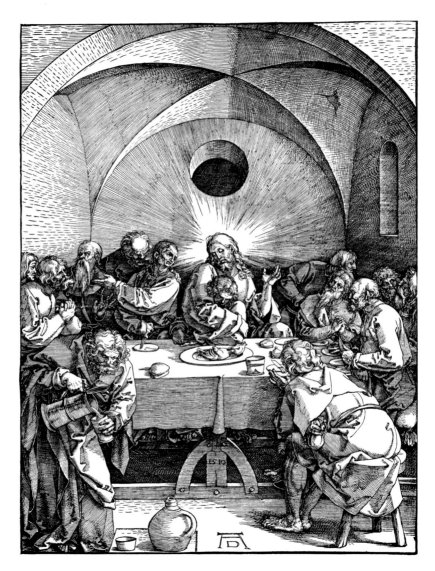

it is noticeable how frequently during the
sixteenth and seventeenth centuries judas
is depicted with red hair – an attribute
which might have been seen as 'devilish'.

hans holbein the younger
tempera on wood
c.1520–4
öffentliche kunstsammlung,
kunstmuseum, basel

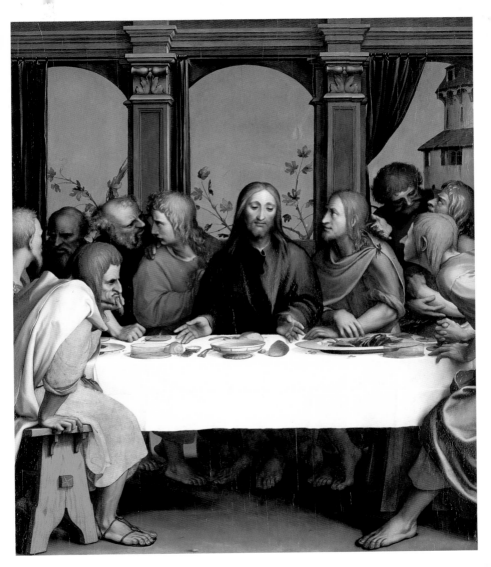

italian school

majolica dish

c.1525

louvre, paris

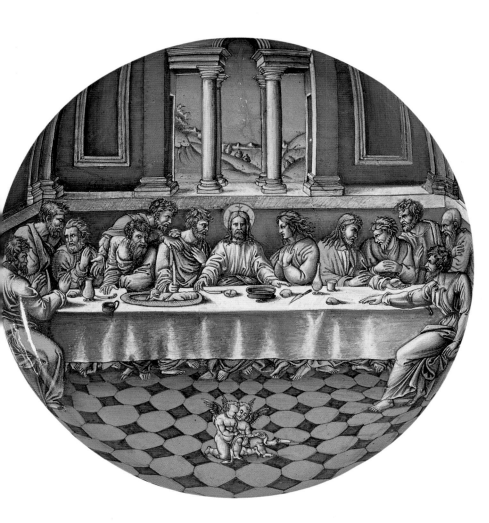

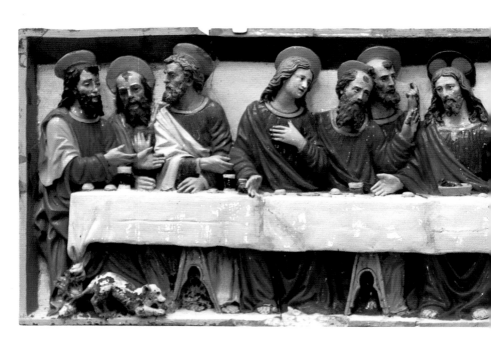

giovanni della robbia

glazed terracotta

c.1525

victoria and albert museum, london

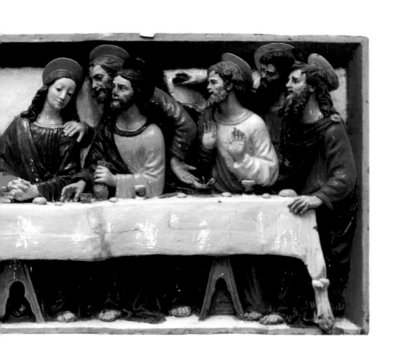

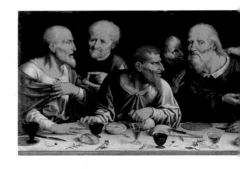

on the far right, the artist has painted
himself into the scene as a servant.

joos van cleve
oil on wood
c.1525–7
louvre, paris

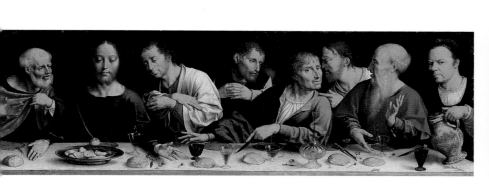

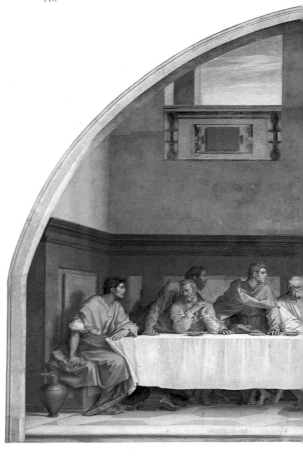

andrea del sarto

fresco

1526–7

convent of san salvi, florence

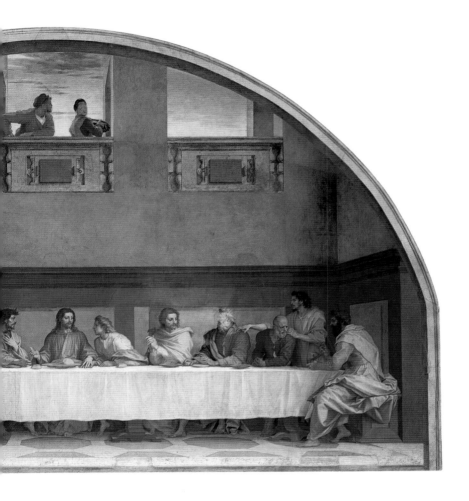

here some of the apostles are represented
by the leading figures of the reformation.
martin luther, who was a close friend of
cranach, appears seated on the right as the
figure who takes a cup from a servant.

lucas cranach the elder
oil on wood
c.1539–47
st marien, wittenburg

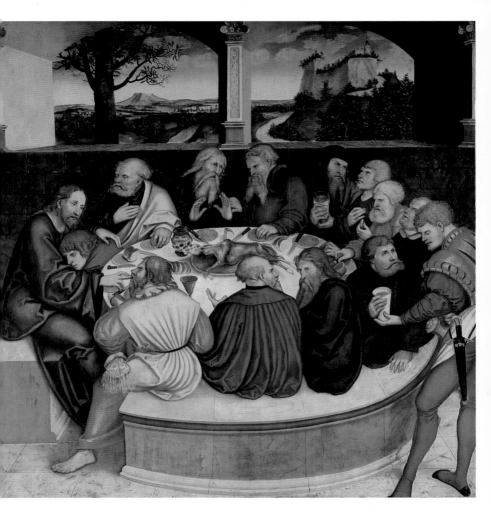

titian

oil on canvas

1542–4

palazzo ducale, urbino

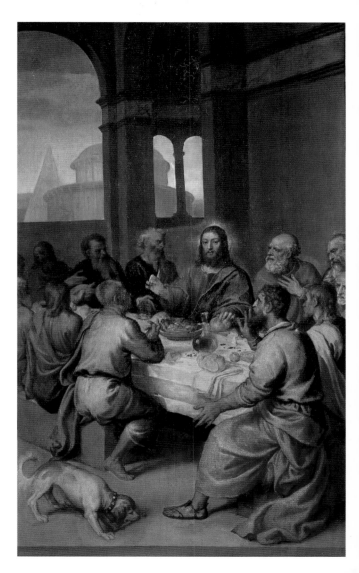

jacopo bassano

oil on canvas

1546–8

galleria borghese, rome

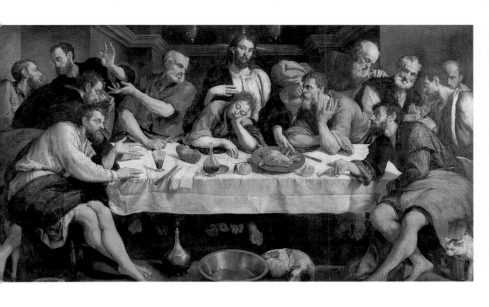

léonard limousin

enamel plaque

1557

musée de la renaissance, écouen

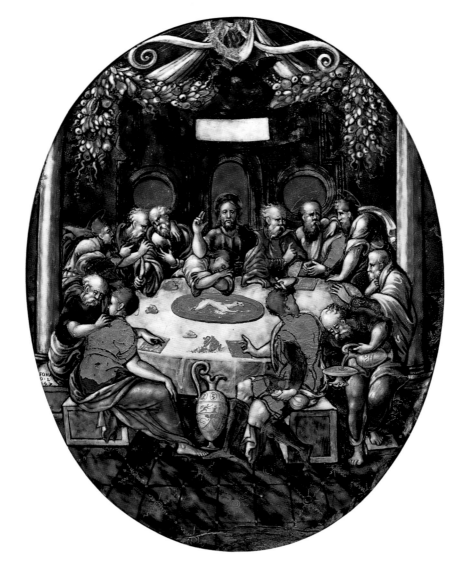

teodoro de holanda

stained-glass window

1559–60

capilla mayor, granada cathedral

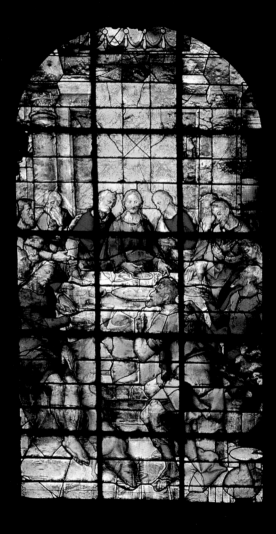

juan de juanes

oil on wood

1560–70

prado, madrid

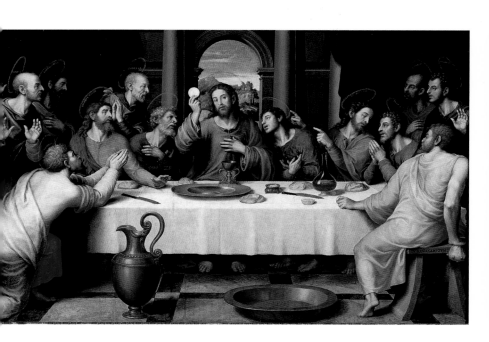

titian

oil on canvas

1564

escorial, madrid

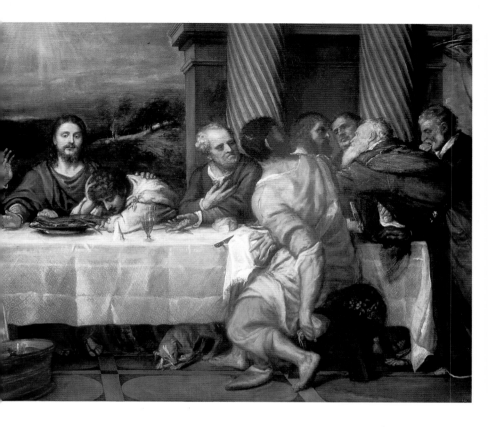

el greco

oil on wood

c.1570–5

pinacoteca nazionale, bologna

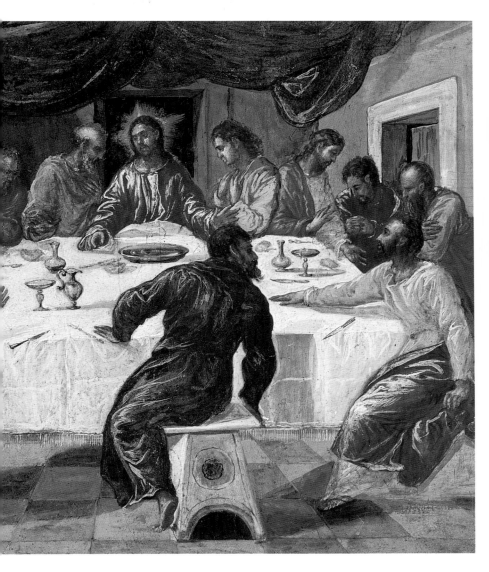

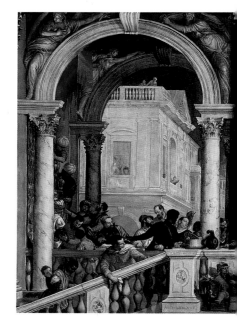

criticized by the inquisition for including
superfluous and 'indecorous' material in
what was originally supposed to be a
representation of the last supper, veronese
simply renamed his painting 'the feast in
the house of levi'.

paolo veronese
oil on canvas
1573
accademia, venice

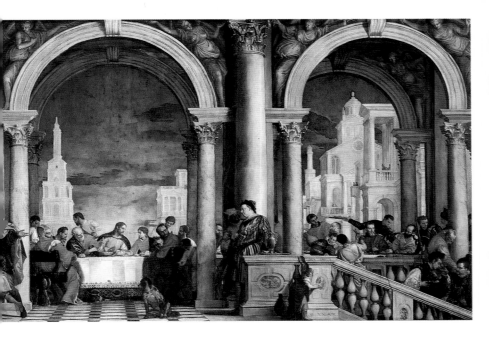

jacopo tintoretto

oil on canvas

1575–88

scuola grande di san rocco, venice

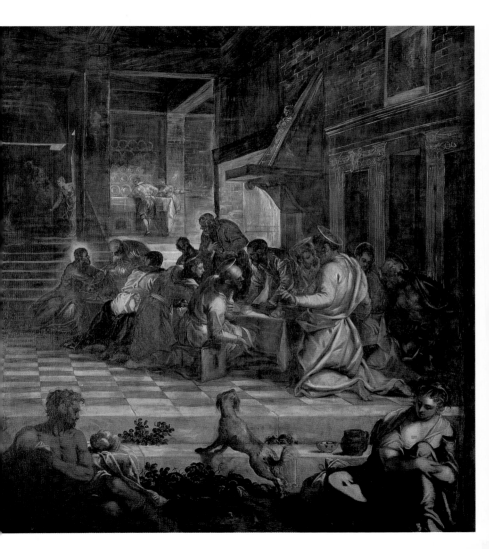

federico barocci

oil on canvas

c.1580

urbino cathedral

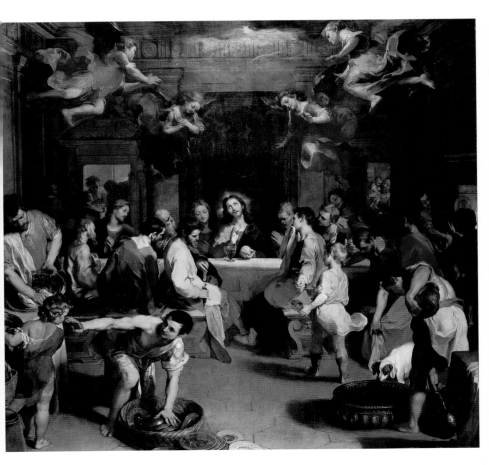

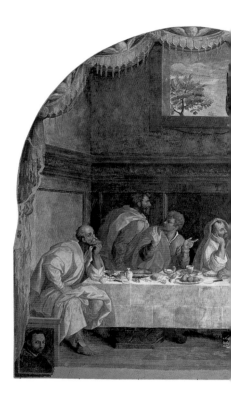

alessandro allori

fresco

1582

chiesa del carmine, florence

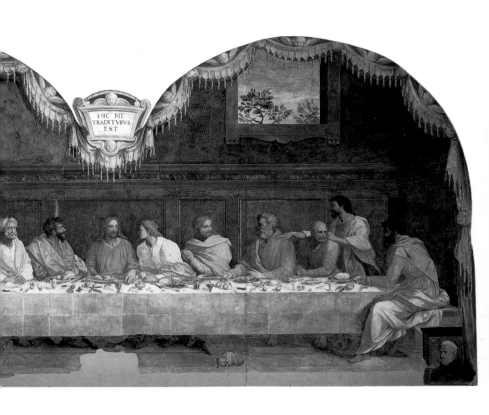

bartolomé carducho

oil on canvas

c.1590

prado, madrid

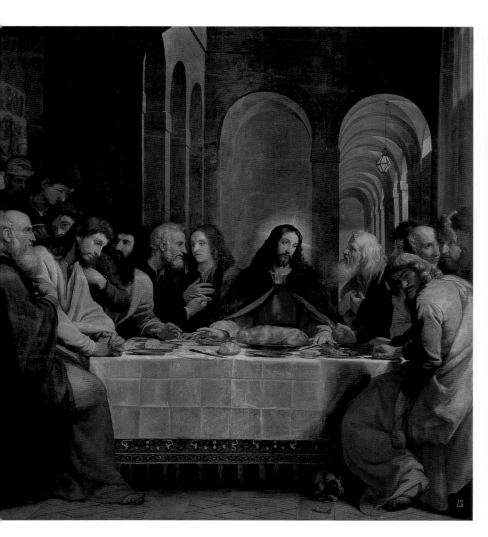

jacopo tintoretto

oil on canvas

1592–4

san giorgio maggiore, venice

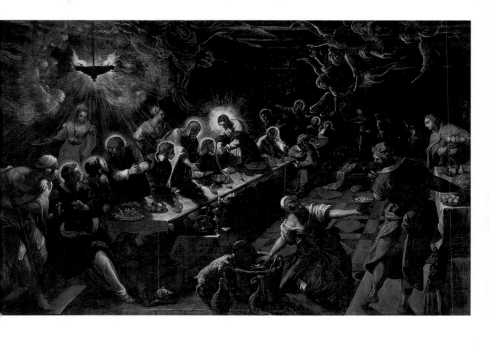

german school
stained-glass window
16th century
victoria and albert museum, london

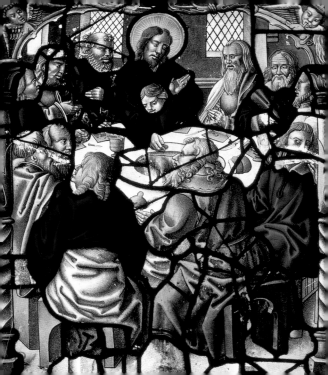

flemish school
tapestry
16th century
uffizi, florence

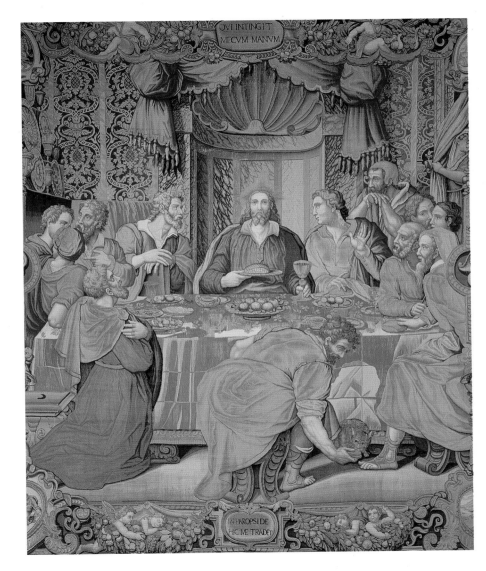

greek school

icon

16th century

icon museum, dubrovnik

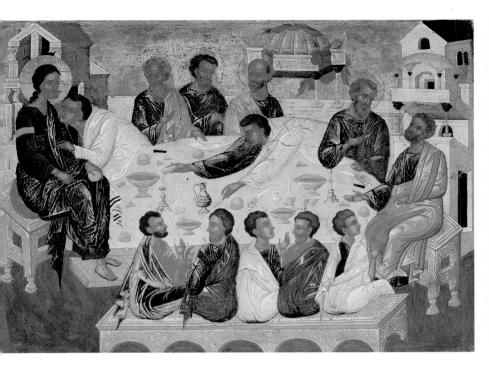

frans pourbus the younger

oil on canvas

1618

louvre, paris

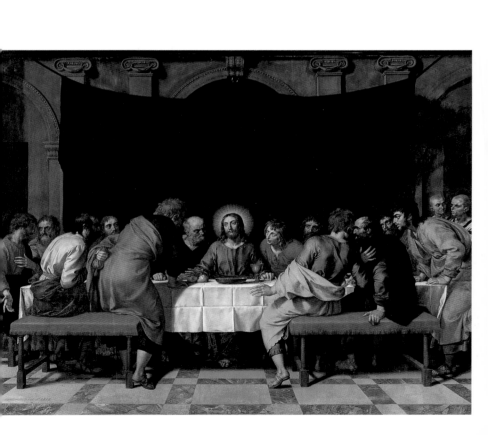

fabrizio boschi

fresco

c.1620

ospedale di bonifacio, florence

daniele crespi
oil on canvas
late 1620s
brera, milan

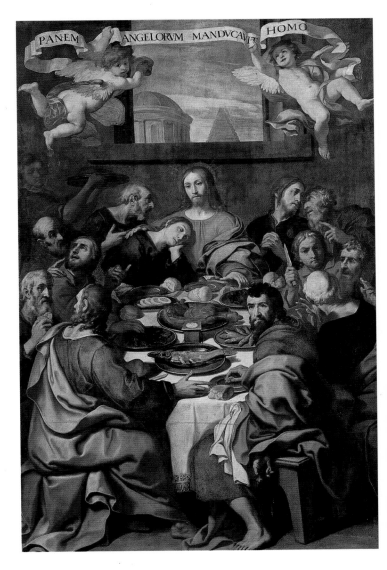

frans franken ii and iii

oil on canvas

c.1630

private collection

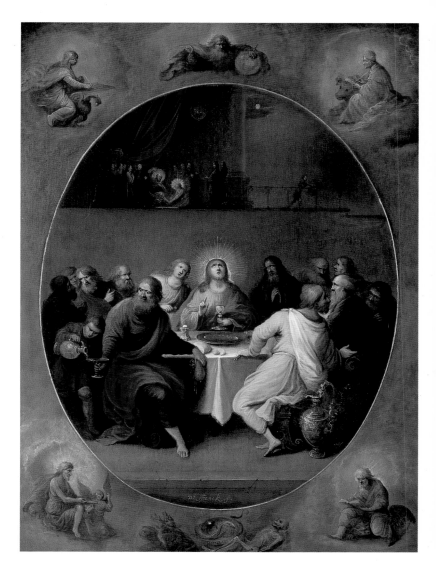

matthieu le nain
oil on canvas
1630–40
louvre, paris

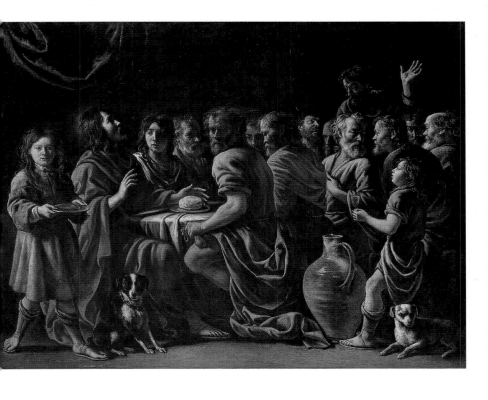

peter paul rubens
oil on wood
1631–2
brera, milan

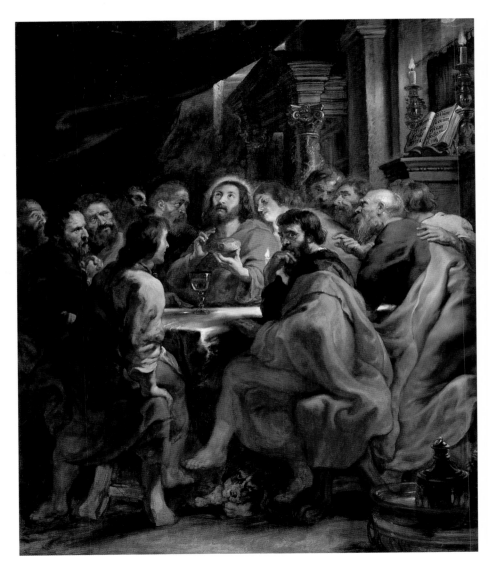

simon vouet

oil on canvas

c.1635–7

musée des beaux-arts, lyon

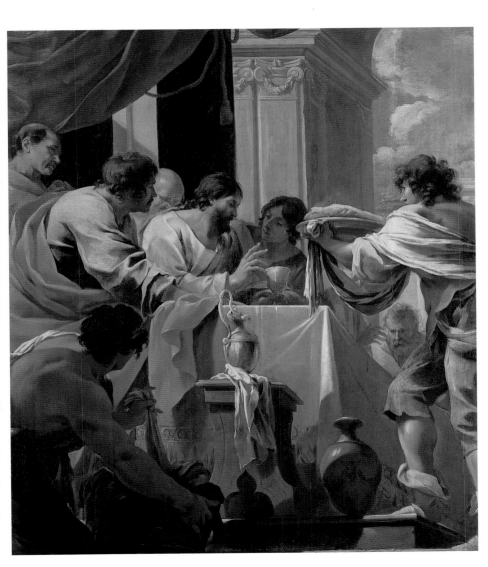

poussin's painting comes from a series
portraying all the seven sacraments
recognized by the catholic church: baptism,
confirmation, communion (commemorated
here), confession, marriage, ordination and
extreme unction. as befits his interest in
the classical, poussin shows the apostles
reclining at the table in the roman manner
rather than sitting. judas can be seen
leaving the room on the left of the picture.

nicolas poussin
oil on canvas
1647
national gallery of scotland, edinburgh

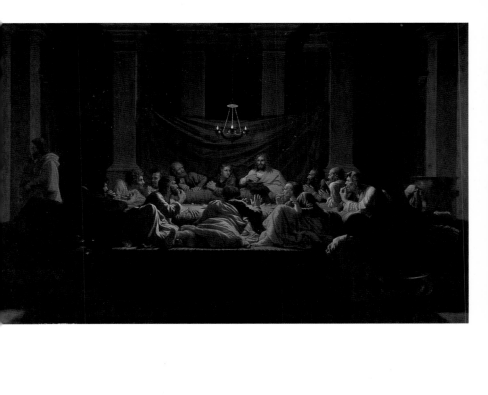

philippe de champaigne

oil on canvas

1652

louvre, paris

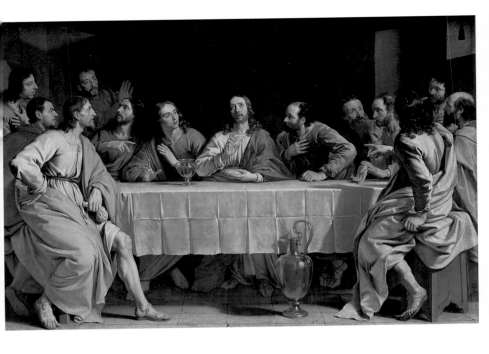

in depicting judas caressing the head of
a dog, the artist is perhaps contrasting
judas's deceitful and treacherous nature
with this traditional symbol of fidelity.

jacob jordaens
oil on canvas
1654–5
koninklijk museum voor schone kunsten,
antwerp

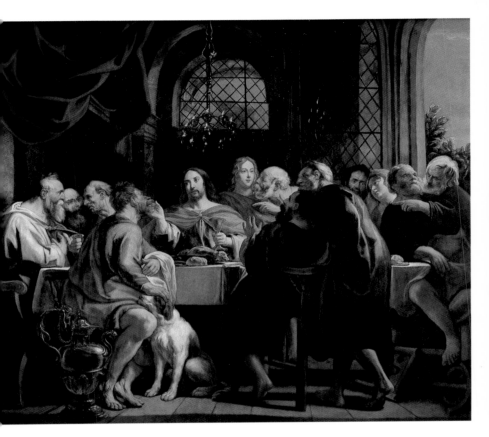

simon ushakov

icon

c.1660

monastery of the holy trinity, sergiyev posad

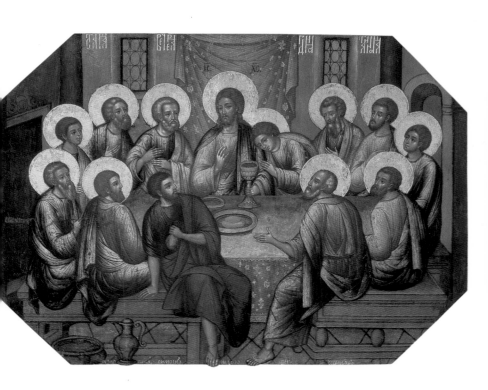

gerbrandt van den eeckhout

oil on canvas

1664

rijksmuseum, amsterdam

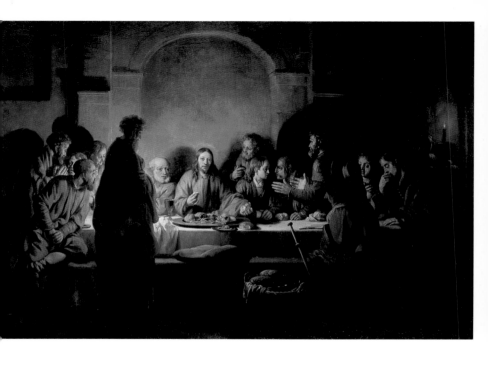

jean-baptiste de champaigne

oil on canvas

c.1678

detroit institute of arts

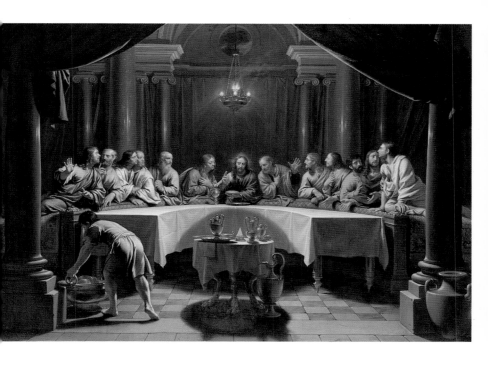

louis de silvestre

oil on canvas

1709

musée de versailles

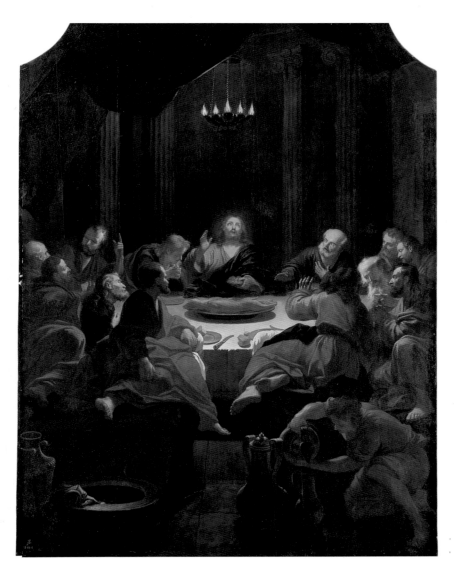

sebastiano ricci

oil on canvas

1713–14

national gallery of art, washington dc

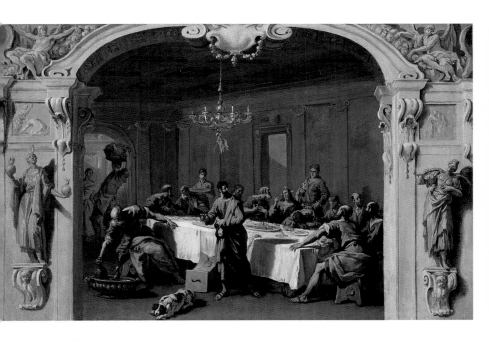

giovanni battista tiepolo

oil on canvas

c.1745–50

louvre, paris

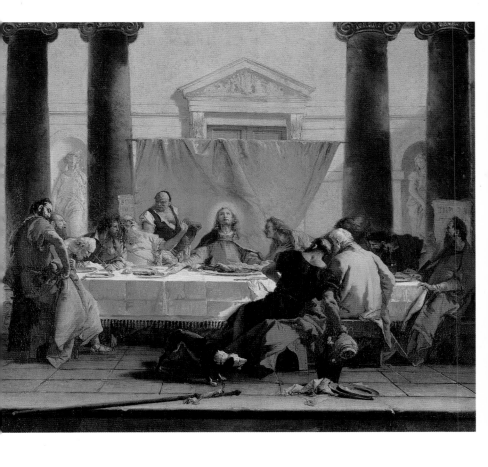

francisco goya
oil on canvas
c.1796–7
santa cueva, cádiz

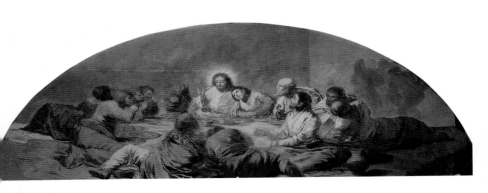

in the foreground of blake's painting we see
an unusually aged judas counting out his
thirty pieces of silver, not even listening
to christ's announcement that he is about
to be betrayed.

william blake
tempera on canvas
1799
national gallery of art, washington dc

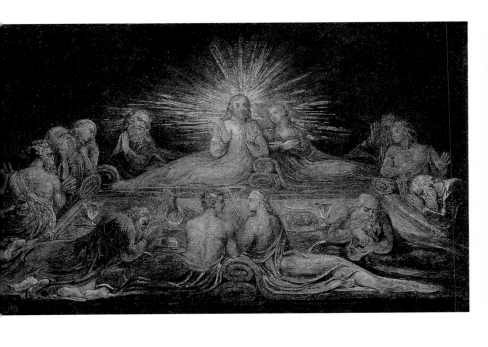

russian school
icon
19th century
private collection

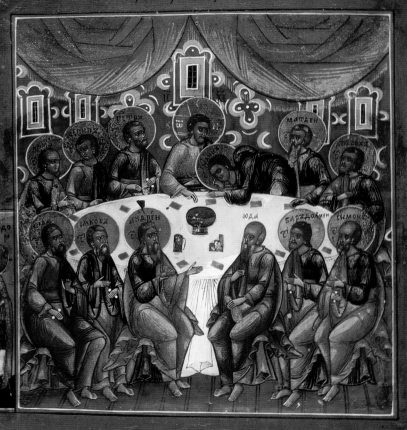

ge's highly original view of the last supper
departs significantly from the traditional
iconography, and presents a highly realistic
view of the event. ge was a member of the
russian artistic group called 'the wanderers'
who sought among other ends to produce a
specifically russian image of christ.

nikolai ge
oil on canvas
1863
russian museum, st petersburg

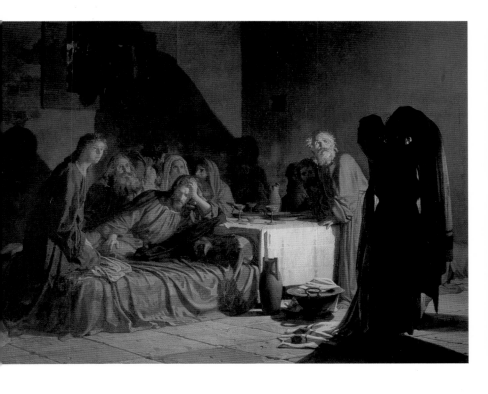

edward burne-jones

pencil on paper

1865

birmingham city museum and art gallery

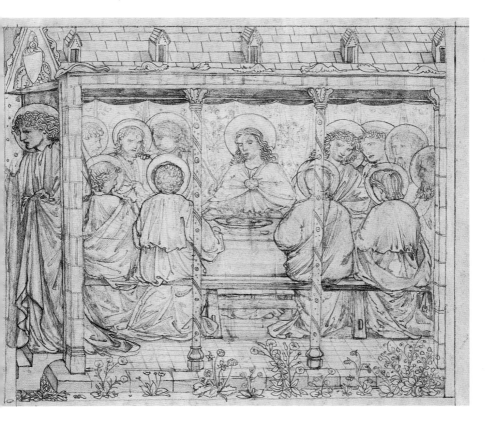

nolde wrote in 1934 of the intense feelings
he experienced while working on the last
supper: 'i painted and painted hardly
knowing whether it was night or day,
whether i was a human being or only a
painter. i saw the painting when i went to
bed, it confronted me during the night, it
faced me when i woke up.'

emil nolde
oil on canvas
1909
royal museum of fine arts, copenhagen

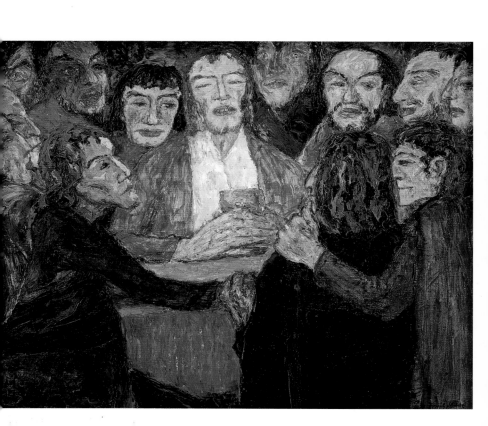

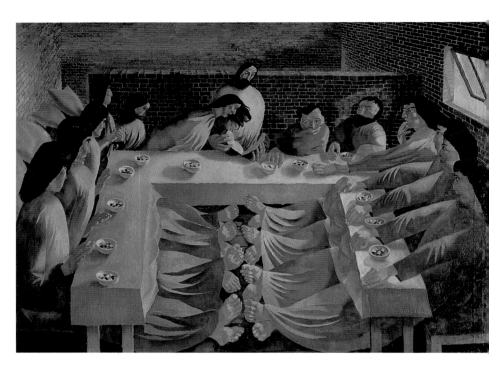

stanley spencer

oil on canvas

1920

stanley spencer gallery, cookham

stanley spencer

oil on wood

1922

private collection

mark tobey

tempera on paper

1945

metropolitan museum of art, new york

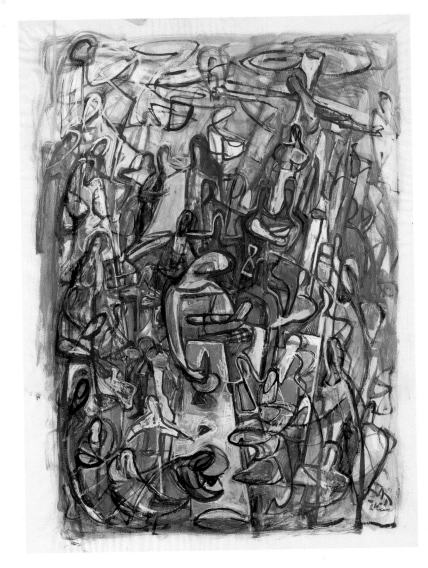

salvador dalí

oil on wood

1955

national gallery of art, washington dc

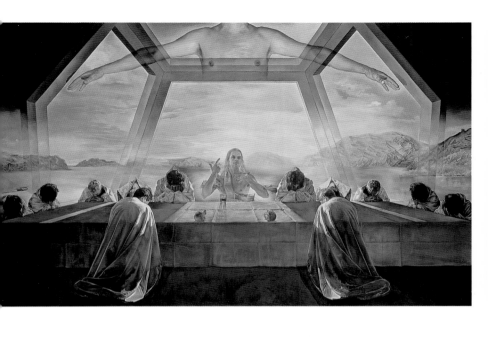

bernard buffet
oil on canvas
1961
collezione d'arte religiosa moderna,
vatican, rome

(overleaf)
ben willikens
acrylic on canvas
1976–9
deutsches architektur-museum,
frankfurt am main

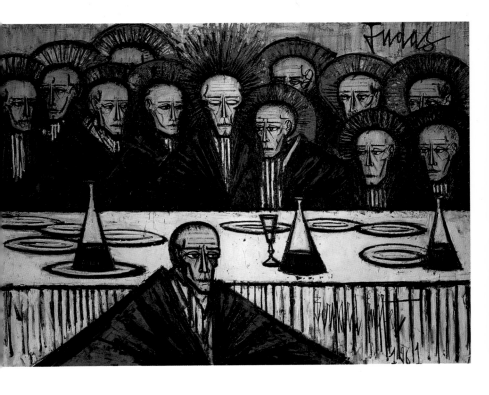

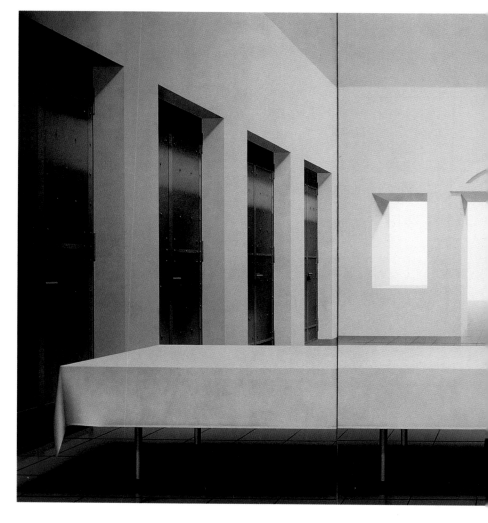

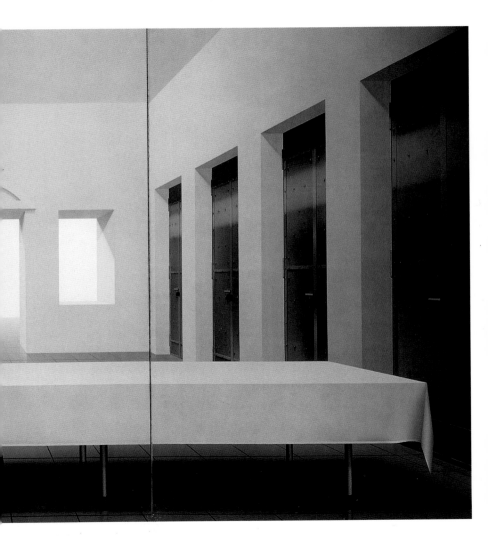

in the last two years of his life, warhol
produced more than twenty large-scale
canvases based upon leonardo's celebrated
last supper. it has been suggested that the
camouflaged version (overleaf) was inspired
by his own ambiguous relationship with the
catholic church – though he regularly
attended church services he would not take
the eucharist or go to confession.

andy warhol
silkscreen and acrylic on canvas
1986
andy warhol museum, pittsburgh

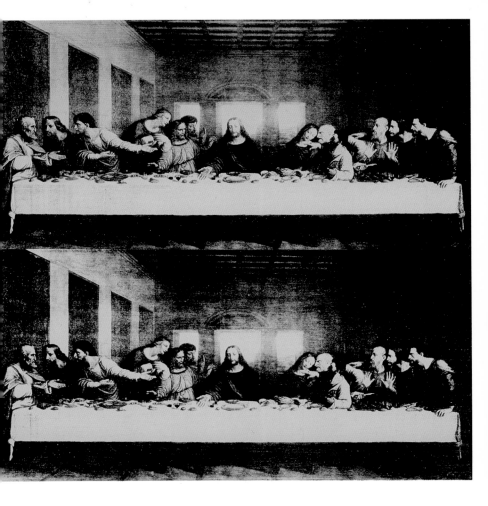

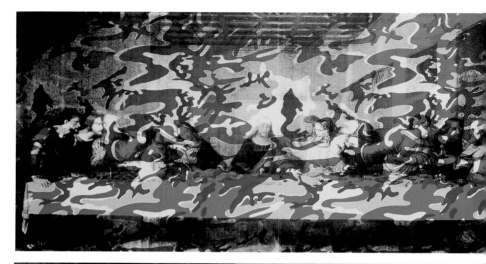

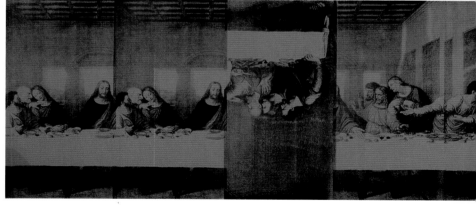

andy warhol

silkscreen and acrylic on canvas

1986

private collection

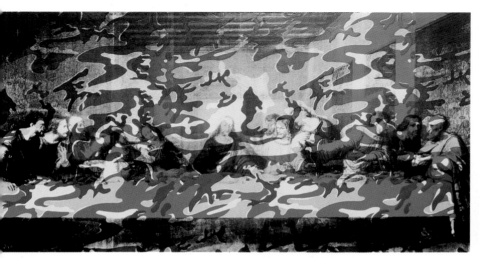

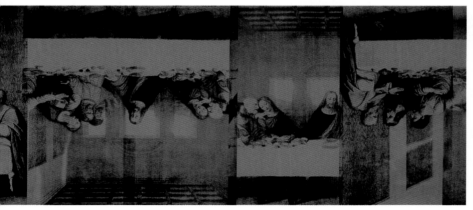

andy warhol

silkscreen and acrylic on canvas

1986

private collection

simon patterson

wall drawing

1990

private collection

Christt

St. Peter

St. John St. Philip
St. Thaddeus St. Bartholomew
St. Andrew Judas St. Simon
St. Thomas St. Matthew

St. James the Less
St. James the Greater

bettina rheims and serge bramley
1997
photographic print

dimensions and additional information
all works are entitled *the last supper* unless
otherwise stated below. where no artist's
name has been specified in the main
caption, the work is anonymous.

p. 5 san apollinare nuovo, ravenna, italy
p. 7 from the gospels of saint augustine
ms. 286, f. 125r
corpus christi college, cambridge, uk
p. 9 8 x 6.5 cm, 3⅛ x 2½ in.
british museum, london, uk
p. 11 from the 'pala d'oro'
san marco, venice, italy
p. 13 from an illuminated antiphonal
abbey of saint gall, switzerland
p. 15 from the book of pericopes of henry ii
clm. 4452, f. 105v
bayerische staatsbibliothek, munich,
germany
p. 17 escorial, madrid, spain
p. 19 st maria in kapitol, cologne, germany
p. 21 from an illuminated gospel lectionary
g. 44, f. 80r
pierpont morgan library, new york, ny, usa
pp. 22–3 sant'angelo in formis, capua, italy
p. 25 from a book of pericopes
bayerische staatsbibliothek, munich,
germany
p. 27 chartres cathedral, france

p. 29 from the floreffe bible
add. ms. 17738, f. 199r
british library, london, uk
pp. 30–1 saint martin, vic, france
p. 33 from the klosterneuburg altarpiece
klosterneuburg abbey, austria
p. 35 choir screen, modena cathedral, italy
pp. 36–7 san marco, venice, italy
p. 39 from the psalter of ingeburg
ms. 9/1695, f. 23r
musée condé, chantilly, france
p. 41 choir screen, naumburg cathedral,
germany
p. 43 scrovegni chapel, padua, italy
p. 45 detail of a panel from the 'maestà'
altarpiece
size of panel 100 x 53 cm, 39⅜ x 20⅞ in.
museo dell'opera del duomo, siena, italy
p. 47 san francesco, assisi, italy
p. 49 pomposa abbey, ferrara, italy
p. 51 40 x 37 cm, 15¾ x 14⅝ in.
accademia, florence, italy
pp. 52–3 collegiate church, san gimignano,
italy
pp. 54–5 41 x 137 cm, 16⅛ x 54 in.
gemäldegalerie, berlin, germany
p. 57 door panel, baptistery, florence, italy
p. 59 san marco, venice, italy
p. 61 24 x 38 cm, 9½ x 15 in.
pinacoteca nazionale, siena, italy

p. 171 296 x 366 cm, 39⅜ x 144¼ in.
koninklijk museum voor schone kunsten,
antwerp, belgium
p. 173 monastery of the holy trinity,
sergiyev posad, russia
p. 175 100 x 142 cm, 39⅜ x 55⅞ in.
rijksmuseum, amsterdam, the netherlands
p. 177 110.4 x 159.2 cm, 43½ x 62¾ in.
detroit institute of arts, il, usa
p. 179 209 x 156 cm, 82¼ x 61⅜ in.
musée national du château de versailles
et trianon, france
p. 181 67.3 x 103.8 cm, 26½ x 40⅞ in.
national gallery of art, washington dc, usa
p. 183 81 x 90 cm, 32 x 35½ in.
louvre, paris, france
p. 185 146 x 340 cm, 57.5 x 133⅞ in.
santa cueva, cádiz, spain
p. 187 30.5 x 48.2 cm, 12 x 19 in.
national gallery of art, washington dc, usa
p. 189 private collection
p. 191 283 x 382 cm, 111⅜ x 150⅜ in.
russian museum, st petersburg, russia
p. 193 37.6 x 51.1 cm, 37¼ x 20⅛ in.
birmingham city museum and art gallery,
uk
p. 195 81.9 x 104.8 cm, 32¼ x 41¼ in.
royal museum of fine arts, copenhagen,
denmark
p. 196 91.5 x 122 cm, 36 x 48 in.

stanley spencer gallery, cookham, uk
p. 197 36 x 59.5 cm, 14½ x 23½ in.
private collection
p. 199 56.8 x 43.8 cm, 22⅜ x 17¼ in.
metropolitan museum of art, new york,
ny, usa
p. 201 *the sacrament of the last supper*
167 x 268 cm, 65¾ x 105½ in.
national gallery of art, washington dc, usa
p. 203 200 x 275 cm, 78¾ x 108¼ in.
collezione d'arte religiosa moderna,
vatican, rome, italy
pp. 204–5 3 m x 6 m, 9 ft 10 in. x 19 ft 8 in.
deutsches architektur-museum,
frankfurt am main, germany
p. 207 101.6 x 101.6 cm, 40 x 40 in.
andy warhol museum, pittsburgh, pa, usa
pp. 208–9 (top) *camouflage last supper*
2 m x 7.7 m, 6 ft 8 in. x 25 ft 5 in.
private collection
pp. 208–9 (bottom) 2 m x 10.1 m, 6 ft 8 in.
x 33 ft 3 in.
private collection
p. 211 private collection

picture acknowledgements

akg london: 173, 189, cameraphoto: 134–5, photo erich lessing: 33, 101; art resource, new york/© the andy warhol foundation for the visual arts, inc./ars, ny and dacs, london 2000: 207; art resource, new york, pierpont morgan library: 21, 67, 99; artothek, peissenberg, photo christoph sandig: 119; bayerische staatsbibliothek, munich: 15, 25; bridgeman art library, london: 22–3, 30–31, 73, 143, 147, 159, 191, 193; british library, london: (add. 34294, f. 138v) 89; british museum, london: 9; master and fellows of corpus christi college, cambridge: 7; detroit institute of arts: gift of ralph harman booth (1926): 177; deutsches architektur-museum, frankfurt am main/© dacs 2000: 204–5; duke of sutherland collection, on loan to the national gallery of scotland, edinburgh, photo antonia reeve: 167; galerie bischofberger, zurich/© the andy warhol foundation for the visual arts, inc./ars, ny and dacs, london 2000: 208, 209; galerie maurice garnier, paris/© adagp, paris and dacs, london 2000: 203; photographie giraudon, paris: 39, lauros/ giraudon: 77, 95; index, florence: 19, 81, 145, photo eikonos, ravenna: 35, photo battaglini: 71,

photo vasari: 123; institut amatller d'art hispanic, barcelona: 75, 127, 185; koninklijk museum voor schone kunsten, antwerp: 171; metropolitan museum of art, new york: george a hearn fund (1946)/© dacs 2000: 199, gift of j pierpont morgan (1917) 103; national gallery, london: 93; national gallery of art, washington dc: chester dale collection/© salvador dalí–foundation gala–salvador dalí/ dacs 2000: 201, rosenwald collection: 187, samuel h kress collection: 181; © nolde-stiftung, seebüll: 195; öffentliche kunstsammlung basel, photo martin bühler: 109; patrimonio nacional, madrid: 17, 130–1; simon patterson, london: 211; bettina rheims, paris: 213; rijksmuseum, amsterdam: 175; rmn, paris: 111, 153, photo blot: 114–5, 125, 179, photo lewandowski: 165, 169, photo raux: 161; scala group, antella, florence: 5, 11, 36–7, 43, 45, 47, 49, 51, 53, 57, 59, 61, 62–3, 64–5, 68–9, 79, 83, 84–5, 86–7, 90–1, 97, 105, 116–7, 121, 129, 137, 139, 140–1, 149, 151, 154–55, 157, 163, 183; sonia halliday photographs, weston turville: 27; staatliche museen zu berlin, bildarchiv preussischer kulturbesitz, photo jürg p anders: 25; stanley spencer gallery, cookham/© the estate of stanley spencer 2000. all rights

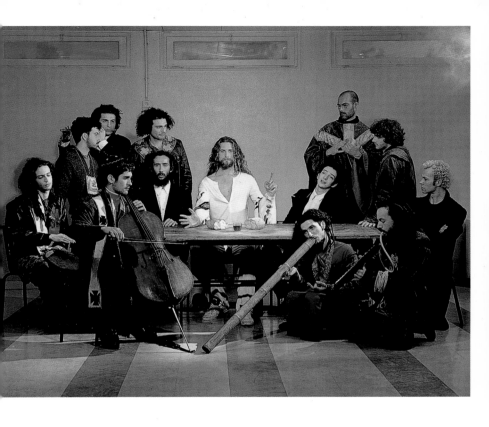